JESSICA FROMM

WHAT IF?

MY FAVORITE NEW HISTORY FACTS 2017

Preface

I spent the 18 months of the election process unable to work as an artist. I could not justify to myself spending the intensive work time in the studio needed to develop a new series of abstract paintings. I felt that the my nation's political situation was so dire, my time would be better spent in direct political action.

But I reminded myself that the artist's role is to goad society, to illuminate the disparities between what is and what might be. I continued to ask myself what approaches to making art which commented on politics were open to me with my particular skills and the history of my oeuvre. Outside events presented themselves to me as cartoon ideas with great frequency…..as, to my great frustration, they did to professional cartoon artists who published theirs long before I could find my own drawing vocabulary. But once I began playing with making collages with appropriated art images I was hooked. I was obsessed with ideas and, as events played out, the scope of the collages varied. Many different approaches became available to me and perhaps another series will follow this one.

The results so far are in this book.

Jessica Fromm

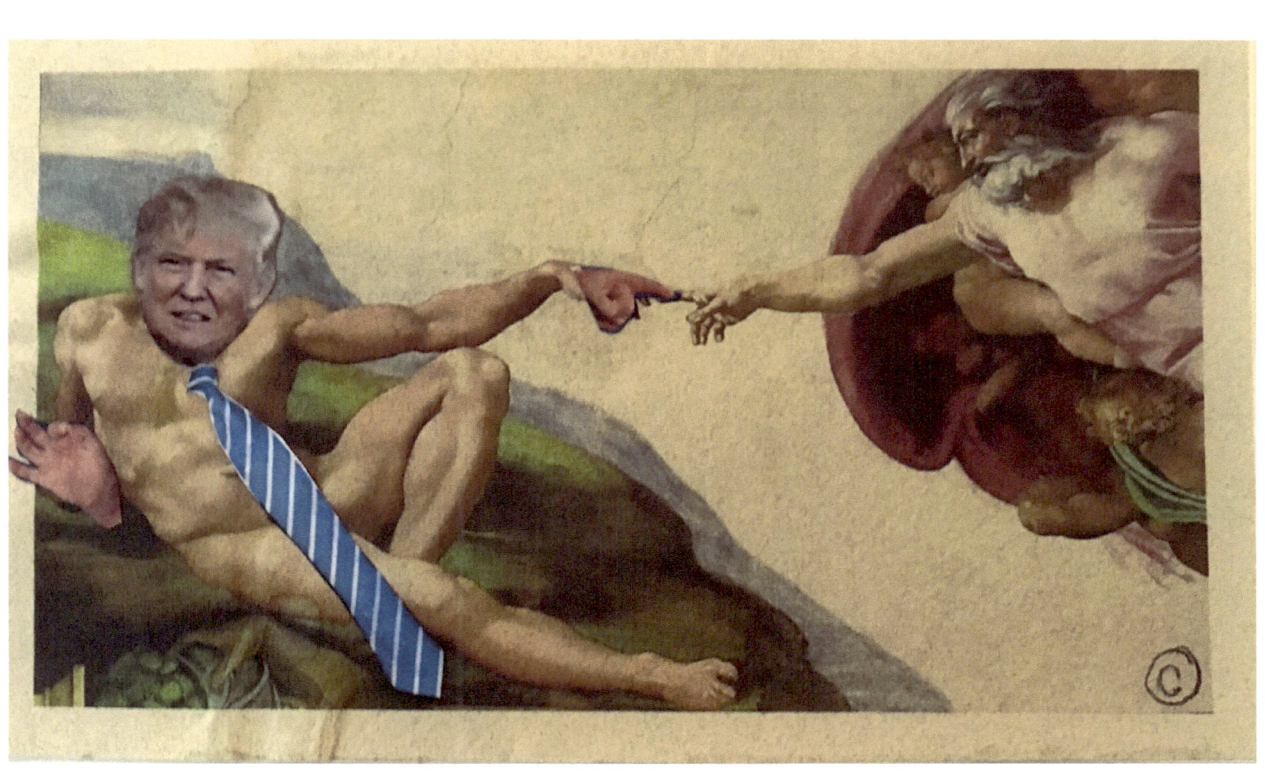

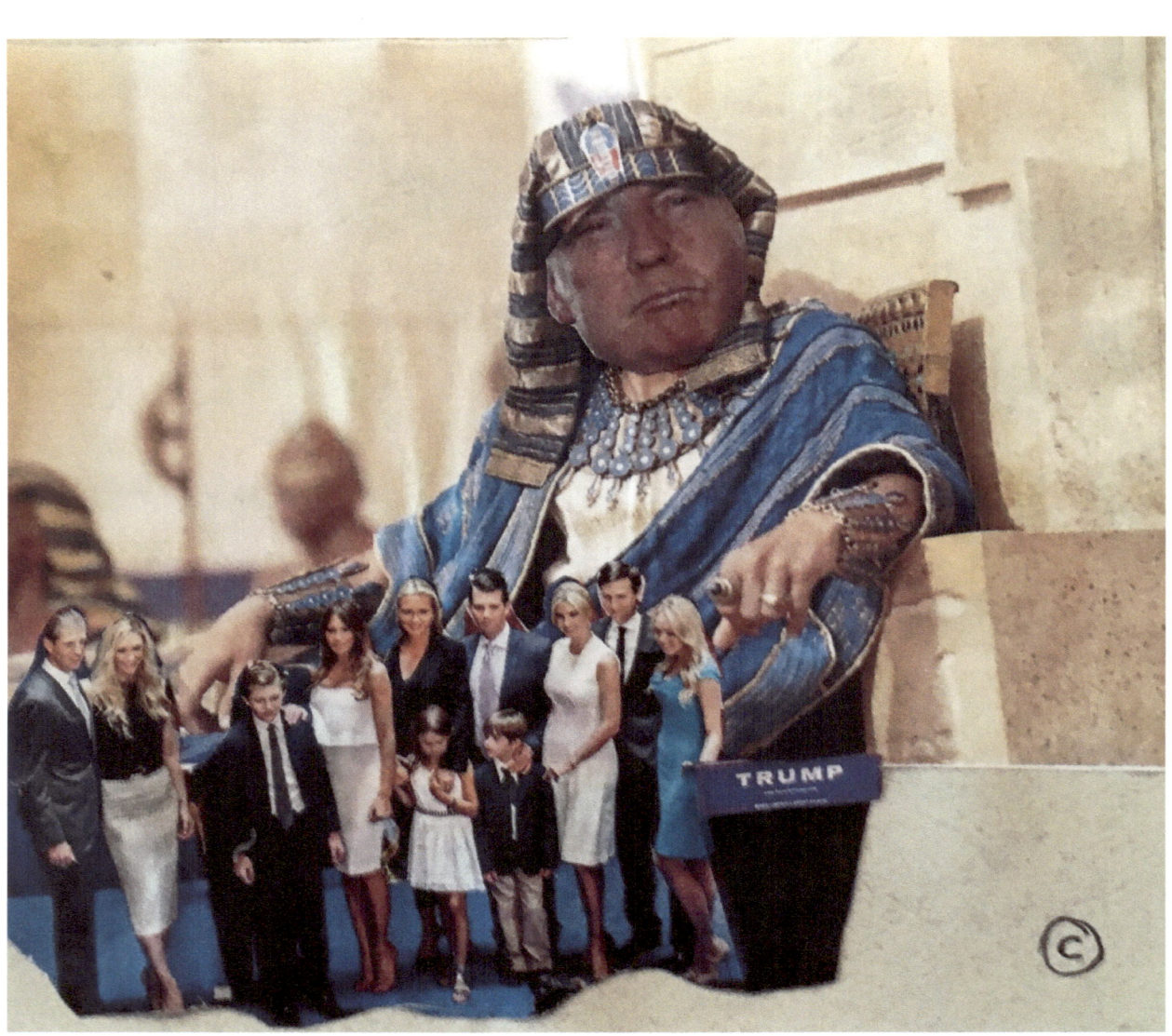

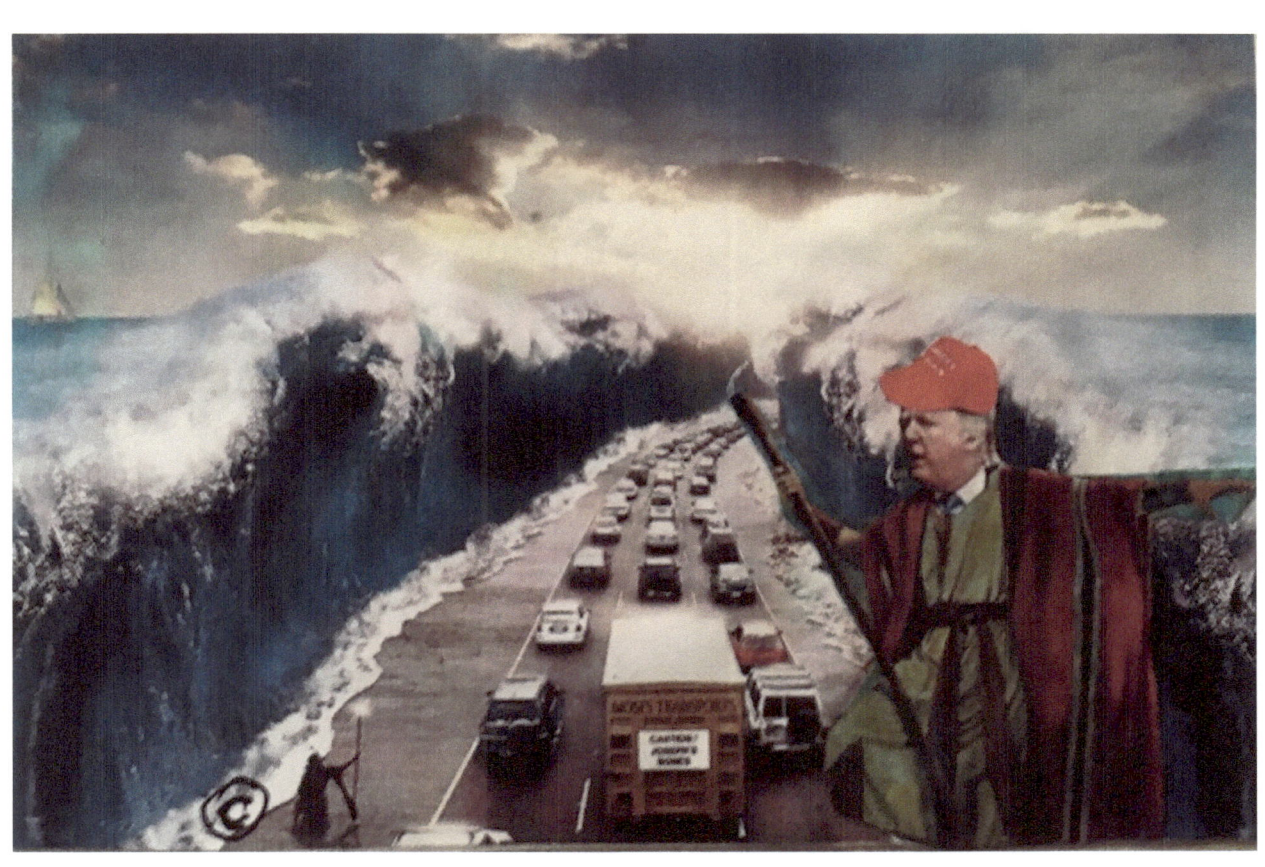

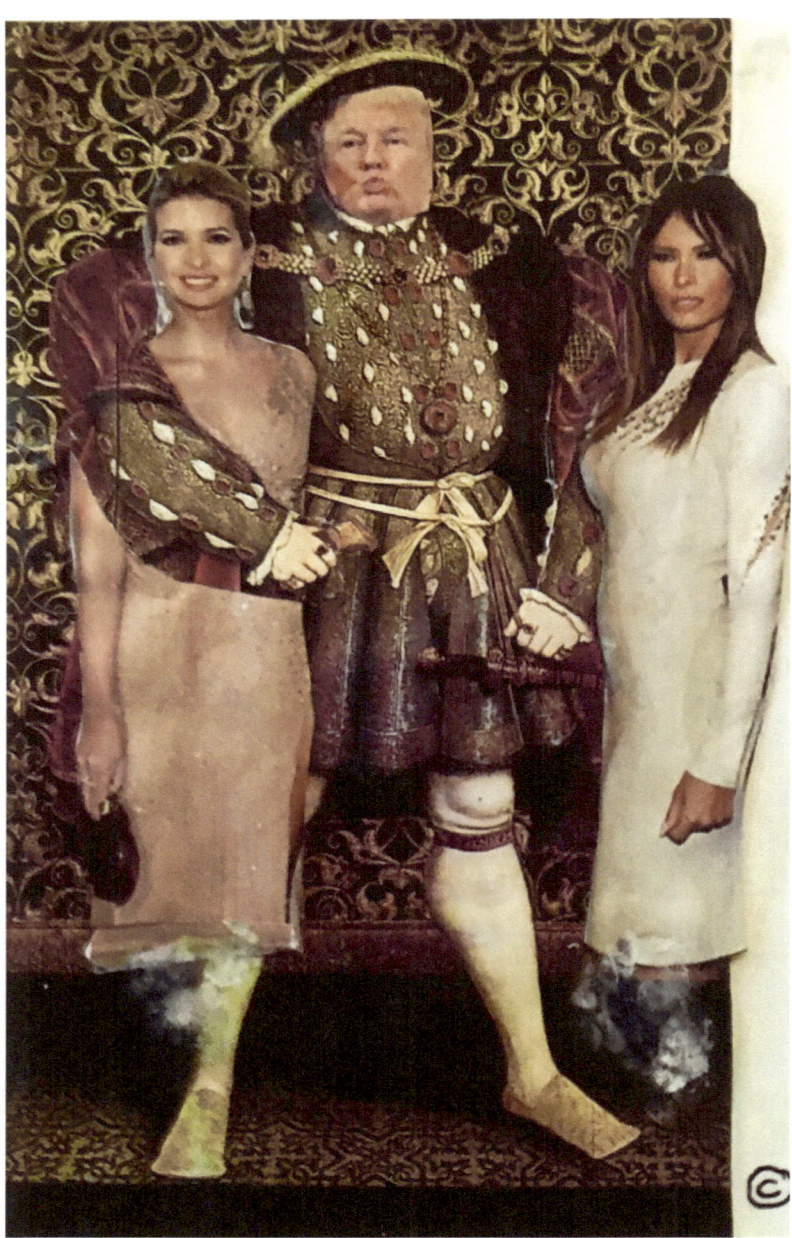

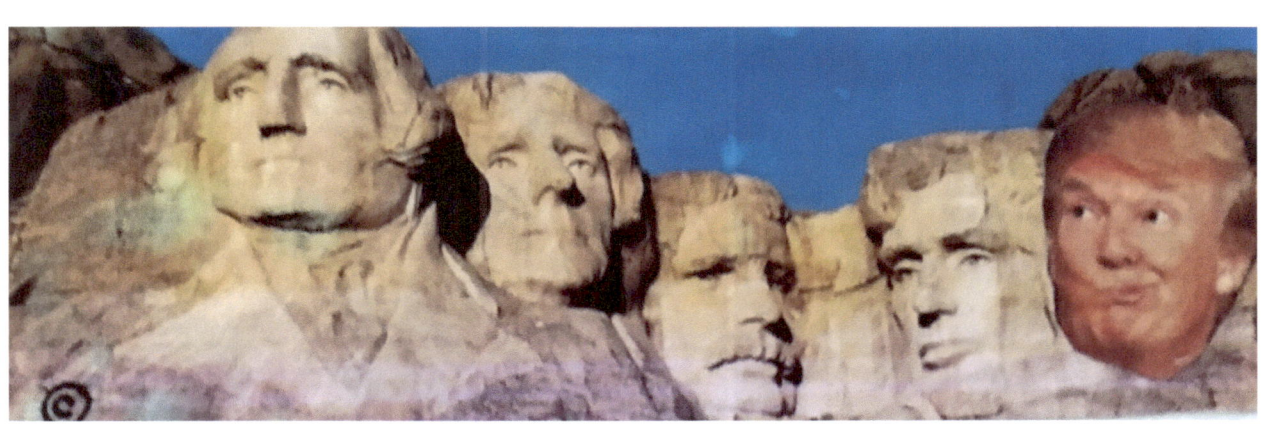

REMEMBERING Camelot

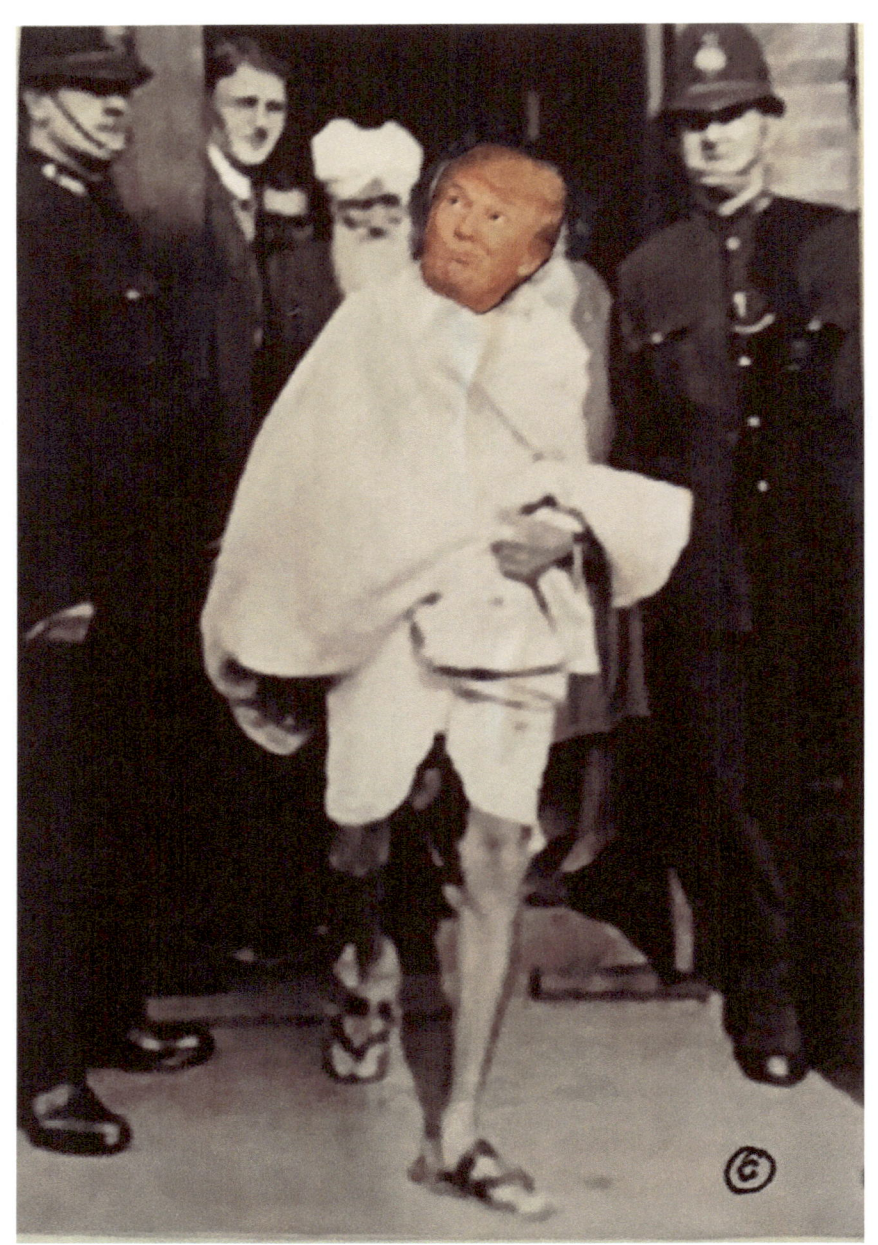

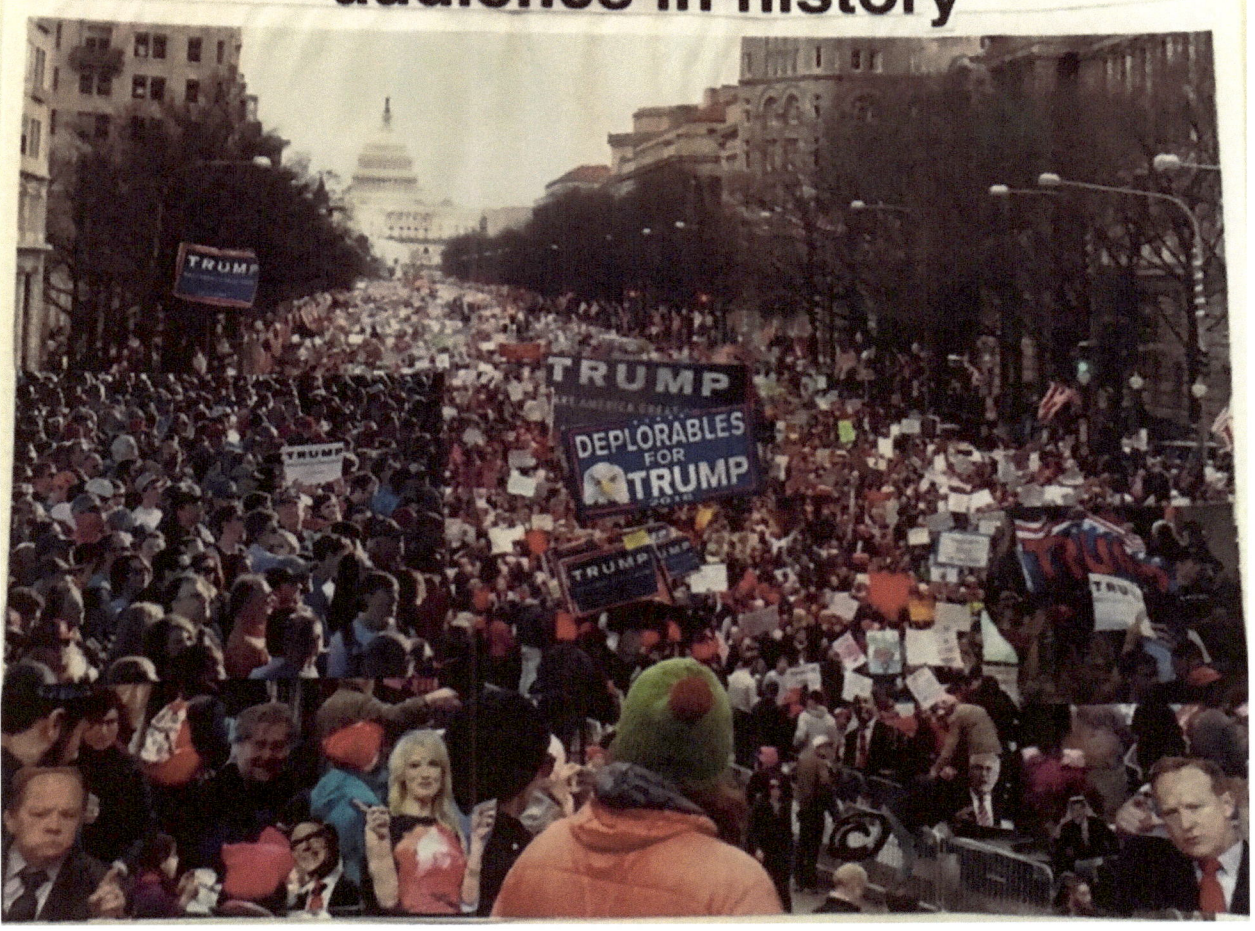

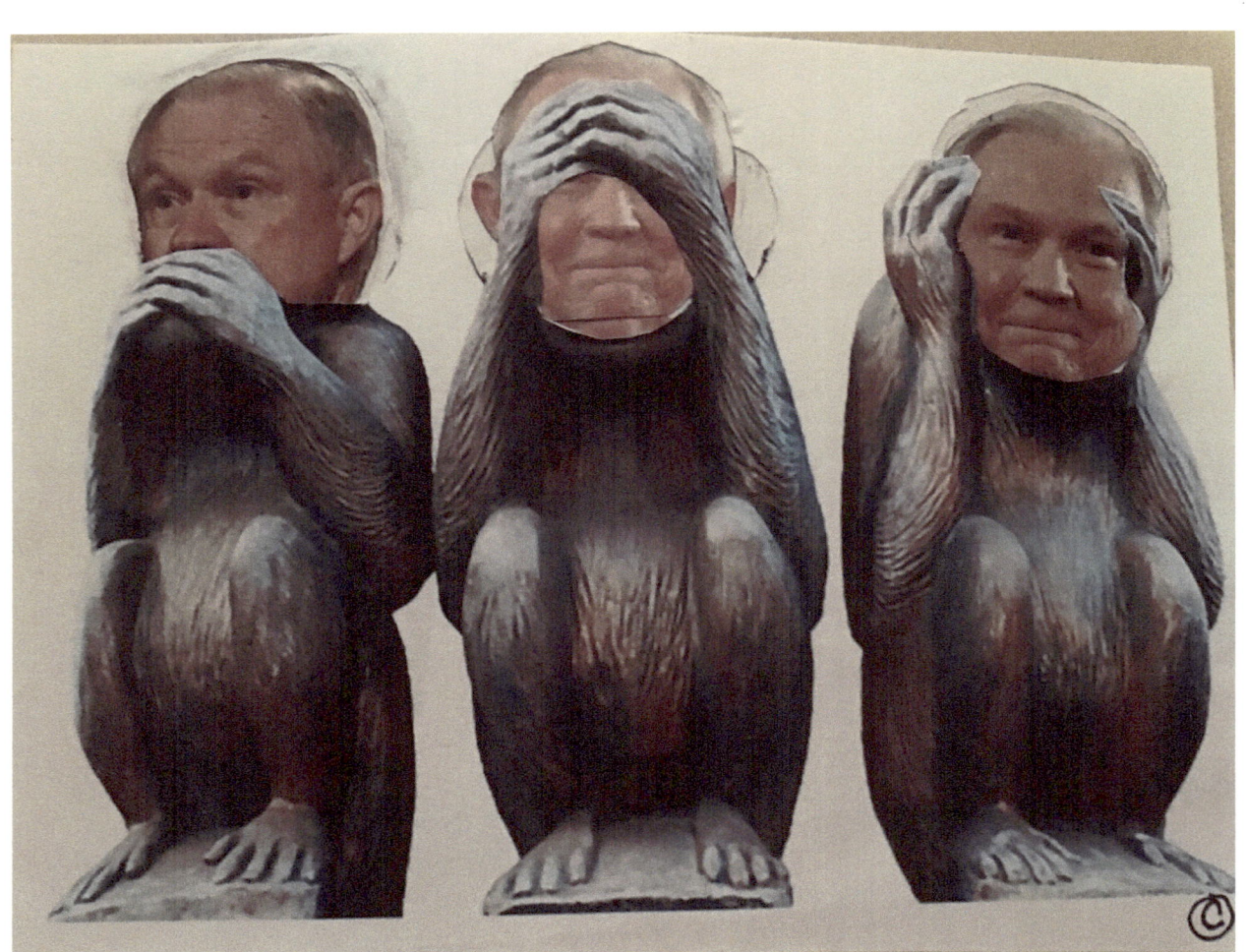

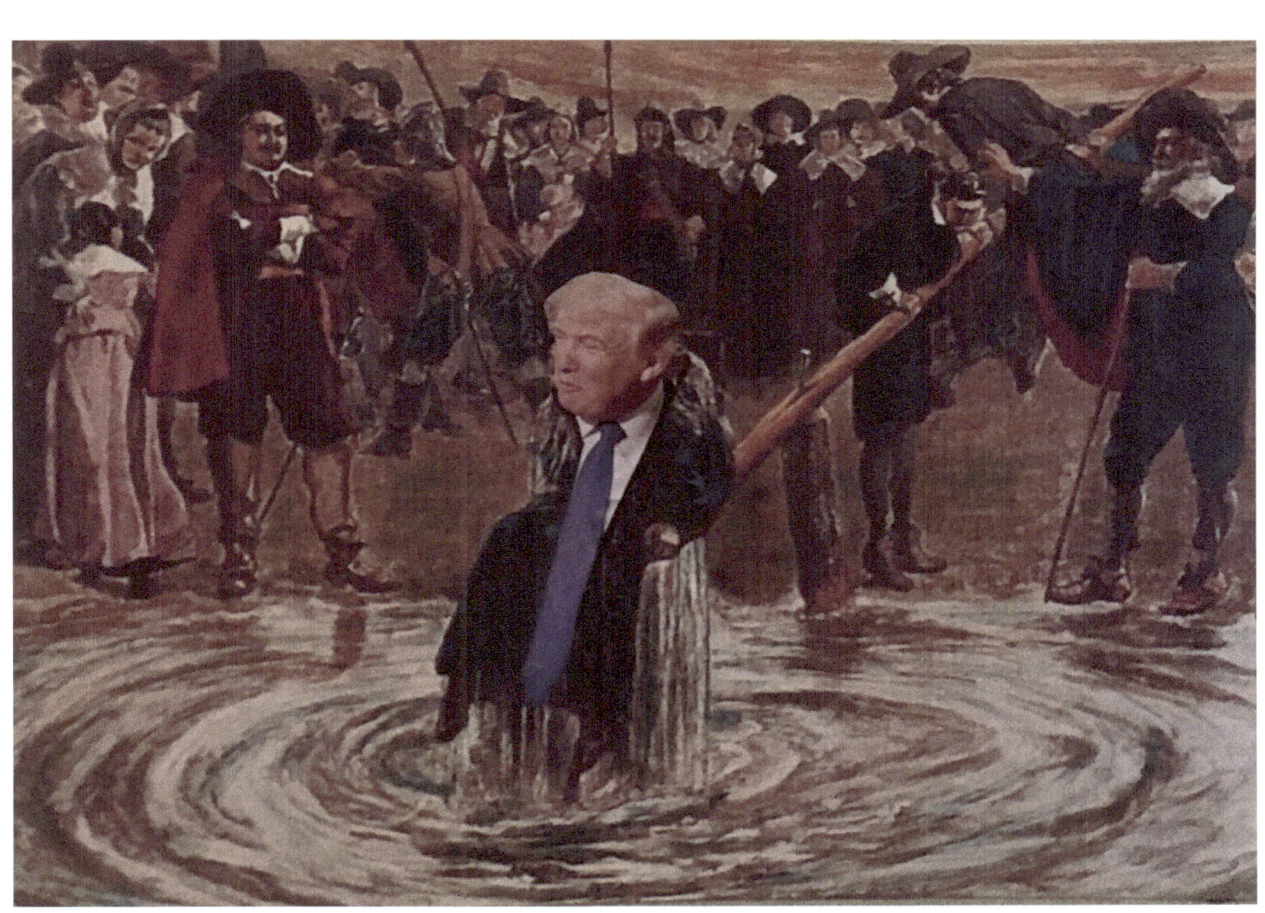

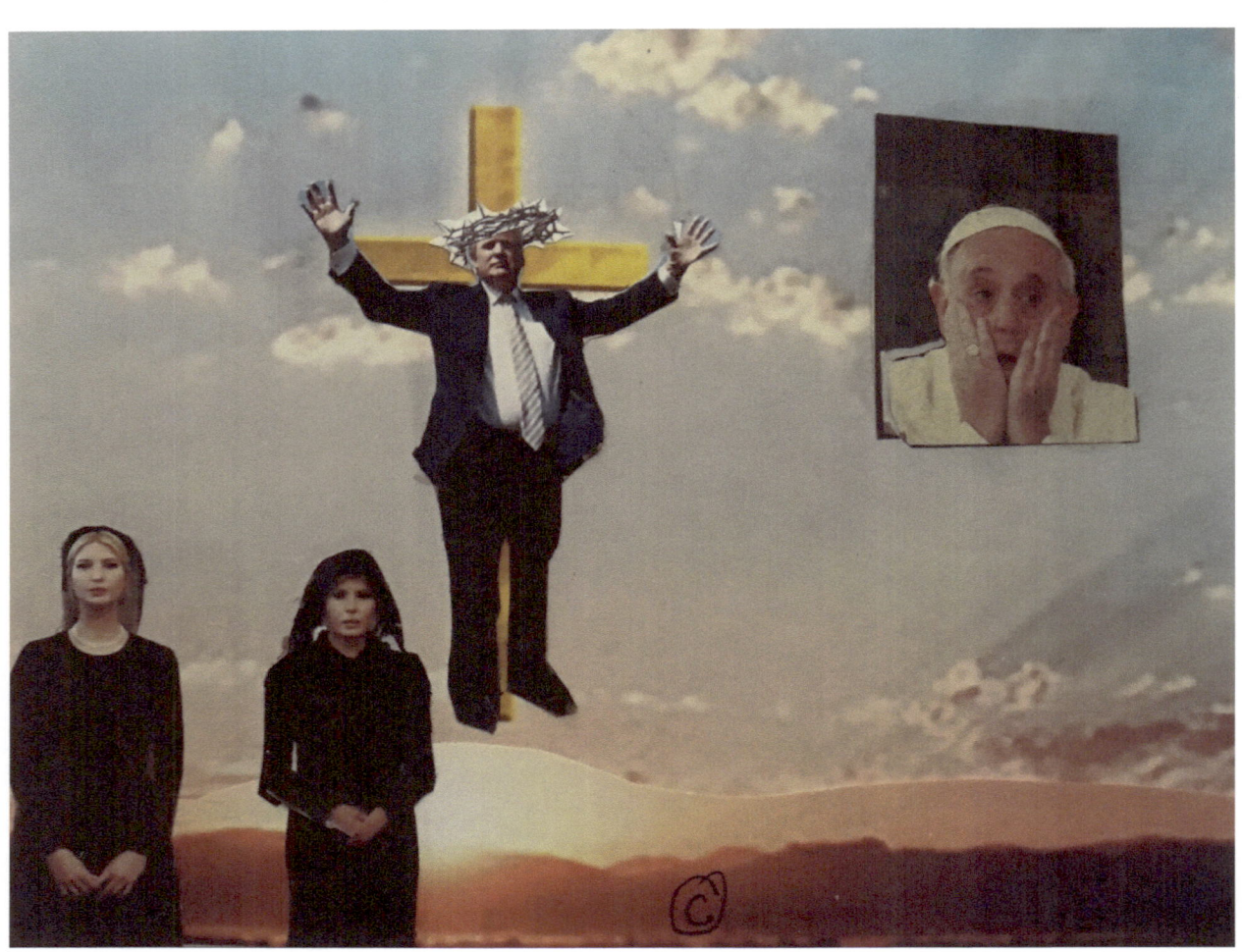

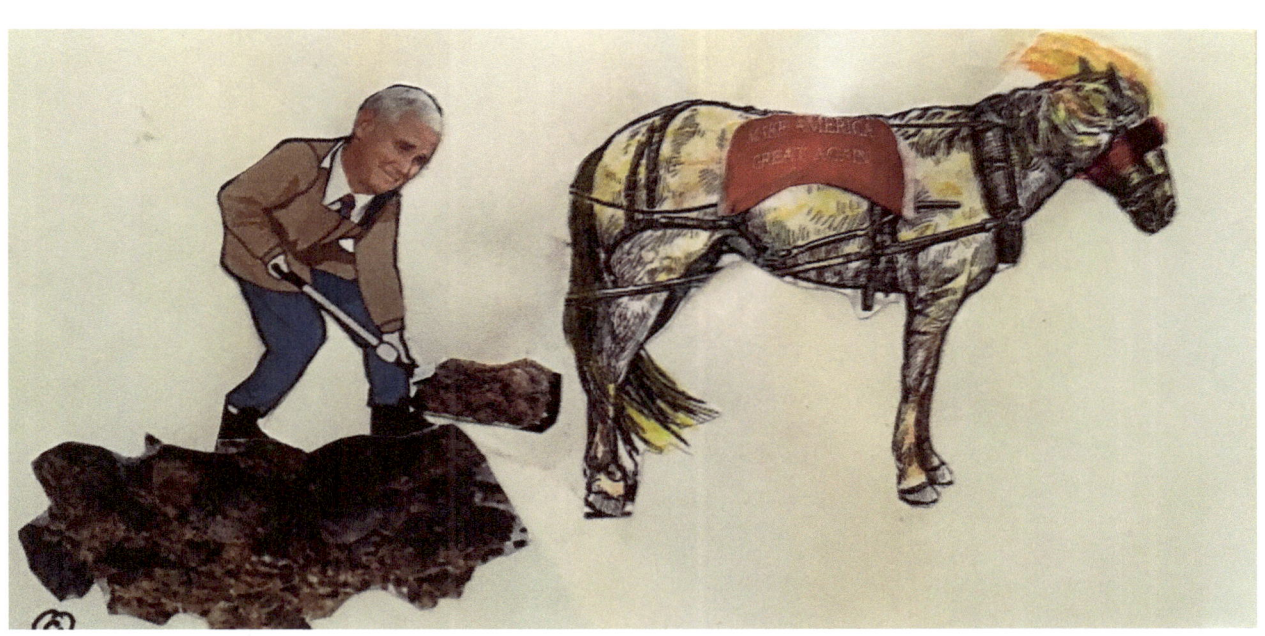

ABOUT the ARTIST

Movement is Jessica's middle name. She has spent her life always dancing but not as a career dancer; a decade career as an Urban Planner; an apprentice cabinetmaker; a fine artist; a metalwork jeweler.

Jessica approached art studies in the hopes of learning to design furniture, but her Basic Drawing teacher, Banerjee, blew the lid off her world by describing drawing as a 'dance on paper'. This she related to her son's finger work on the piano keys to vary his sound and led her to understand that ALL ART is related. From that point on she left furniture design in the past and concentrated on painting.

Jessica Fromm has been showing her artwork as artist-member of Noho Gallery since 1997. Mostly exhibiting as an Abstract Expressionist painter, Jessica is an Expressionist by nature, with movement and feeling also propelling the semi-abstract drawings which she presented in 2 shows at Noho, "Drawing" 2011 and "The Figure", 2012.

This book represents the artist's first venture into politically themed work. She hopes it is only a new beginning.

Copyrights ©2017 by Jessica Fromm
The book author retains sole copyright of
contributions to this book

www.ingramcontent.com/pod-product-compliance
Lightning Source LLC
Chambersburg PA
CBHW041308180526
45172CB00003B/1019